Georges Rouault

GREAT ART OF THE AGES

———————

Georges

GREAT ART OF THE AGES

Rouault

Text by JACQUES MARITAIN

Harry N. Abrams, Inc. Publishers New York

ON THE COVER:
Christ and the Apostles
Collection Mr. and Mrs. Jacques Gelman, Mexico, D. F.

MILTON S. Fox, *Editor-in-Chief*

Standard Book Number: 8109-5136-3

Library of Congress Catalogue Card Number: 69-19715

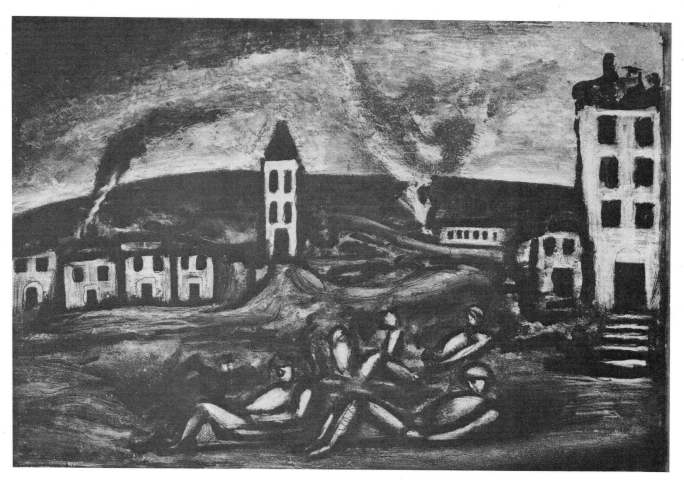

Georges Rouault

(1871–1958)

ROUAULT LIKED TO RECALL THE FACT THAT HE was born in a cellar during the Prussian bombardment of Paris in 1871. From the darkness of this birthplace, in the underground recesses of our ungrateful earth, to the light of the freest and most powerful blossoming forth of the spiritual energies of art—thus I see his story. When we first met him, he was engaged in a particularly somber phase of that "struggle of the spirit" of which Rimbaud spoke, and which is "harder than the struggle of man." He was disregarded, forsaken, condemned by his friends and fellow painters, who charitably lamented the way in which the author of *The Child Jesus among the Doctors* had turned mad and wasted his promising gifts—and at the same time he was searching within himself in obscurity, with that kind of anguish which belongs to great discoverers, and which is not really anguish, for in it dwells the certainty of an inner infallible calling, and it nourishes heroic stub-

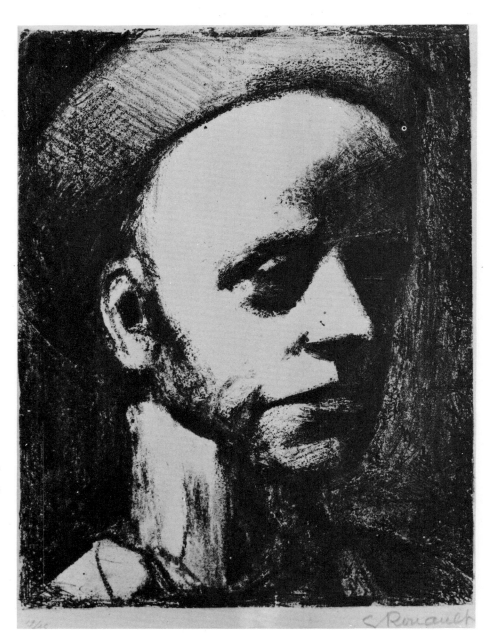

SELF-PORTRAIT
1926. Lithograph

bornness. Later Rouault, at the peak of his glory, entered the realm of the master classics of painting. He had solved the life-and-death problems of modern painting for himself and in his own way, by dint of concentration and strenuous work. Yet this way is a way in which one walks alone. After having stored in his mind a treasure of knowledge and experience on which a generation of searchers could live, but which is incommunicable, every great creator is more solitary than ever. It is through his work that the communication takes place: let him understand who can.

The point I should like to make deals with the superior power of vital synthesis—triumphing over the contrasting requirements and contrasting dangers with which the creative mind meets— an outstanding example of which is offered us by Rouault.

What struck the eye at first in Rouault's art—what strikes the eye still more today—is its rev-

6

OPPOSITE PAGE:
THREE NUDES
Painted about 1907. Oil and gouache, 39 1/2 × 25 1/2"
The Abrams Family Collection, New York

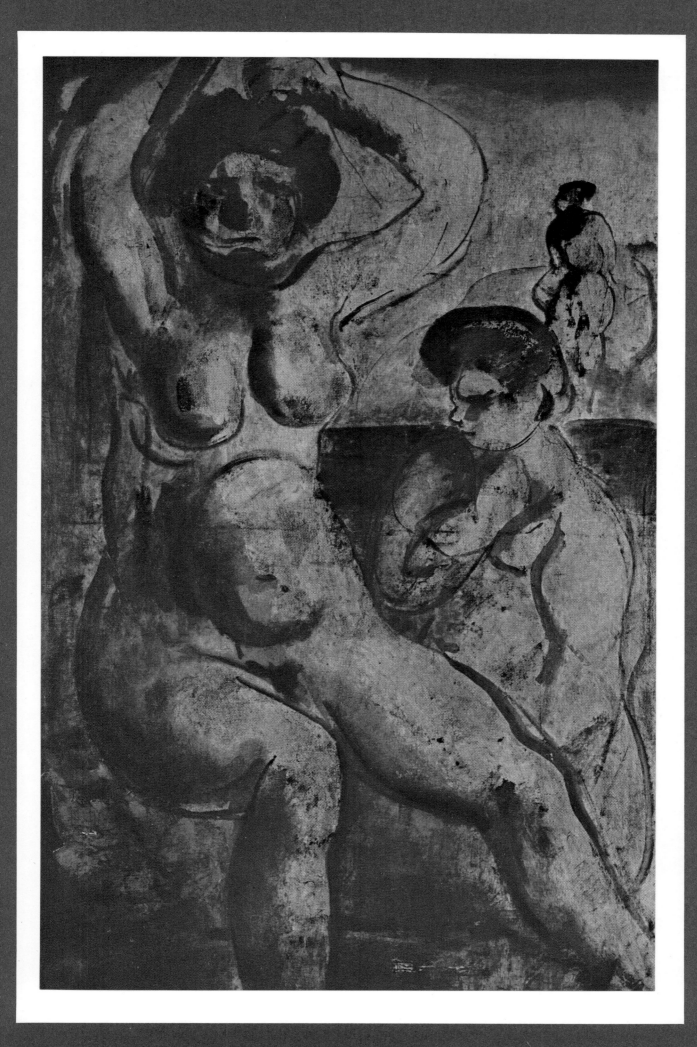

olutionary aspect. All usual canons of beauty are shattered. Yet in proportion as the movement and internal exigencies of this art developed, its deep-rooted continuity with the masters of the past appeared more and more clearly. The relationship of a creative artist with his educators is an ambiguous one. First he is intent on appropriating both the working secrets of their craft and the moral virtues which animate them. Thus did young Rouault's love convey to him, in a kind of dawn knowledge, the influence of Gustave Moreau and of Rembrandt. But then a need for liberation awakens, perhaps the most vital effect of the true understanding of masters. Rouault's liberation from Moreau was definitive as concerns painting, however deep and lasting remained his gratitude and faithfulness to the human and intellectual qualities of the one who recognized his genius from the very start, yet had, so to speak, only an accidental impact on his art. Things were more involved and complex in the case of Rembrandt. A violent reaction against the hold of Rem-

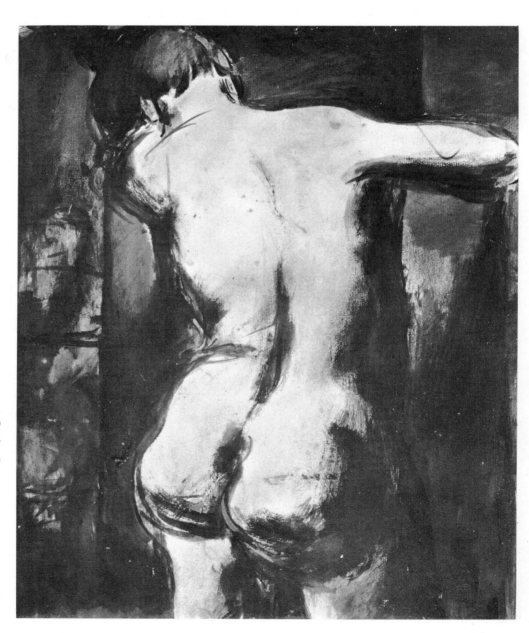

NUDE TORSO
About 1906. Gouache
The Art Institute of Chicago

OPPOSITE PAGE:
PARADE (*The Sideshow*)
Painted in 1907. Gouache and pastel, 26 × 38"
Private collection, Montreux, Switzerland

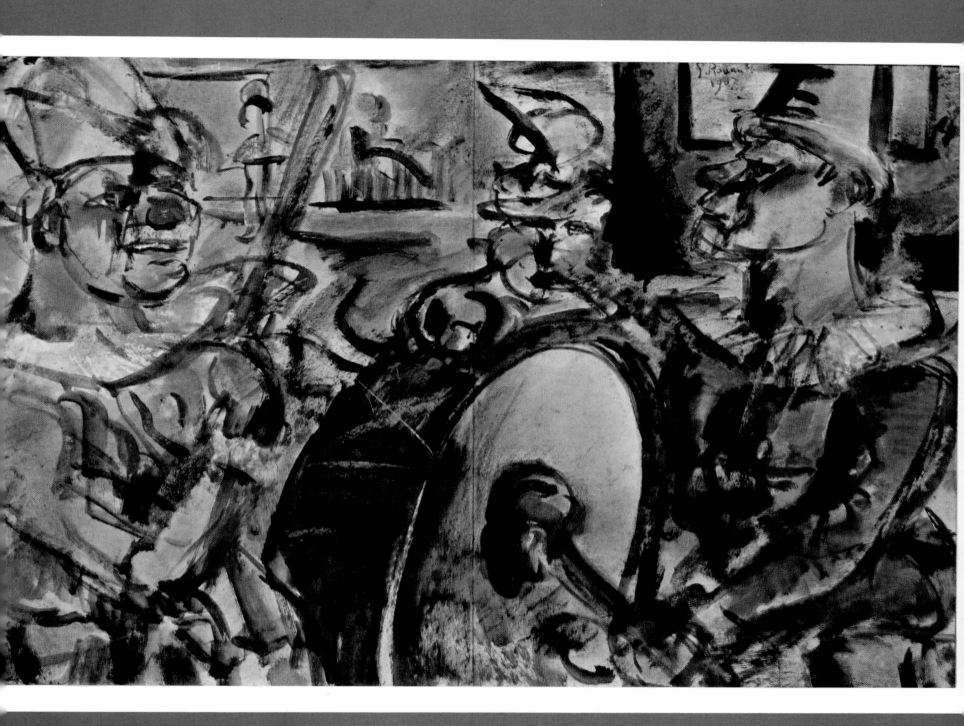

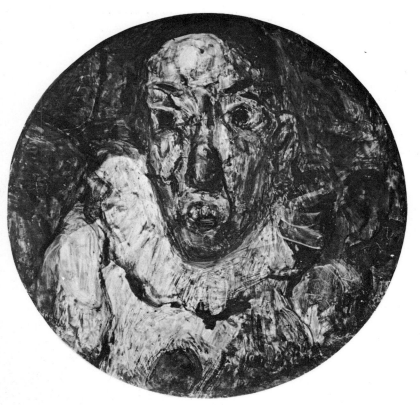

PIERROT
1911. Oil on porcelain
Collection Norbert Schimmel, Great Neck, New York

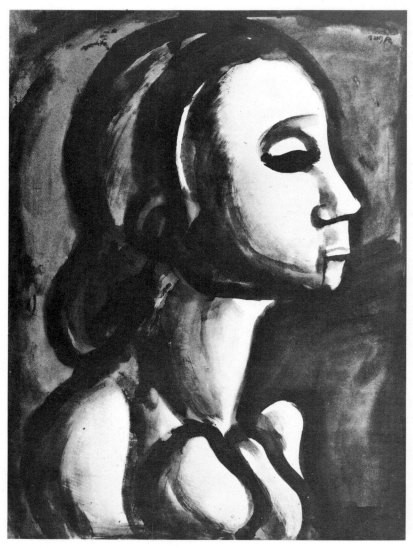

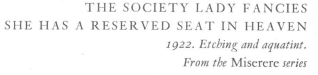

THE SOCIETY LADY FANCIES
SHE HAS A RESERVED SEAT IN HEAVEN
1922. Etching and aquatint.
From the Miserere *series*

brandt coincided with the moment when Rouault became aware of his own inner, creative needs. It was a question of saving his soul as a painter. Not only were the chiaroscuro and other technical means of Rembrandt rejected, but Rembrandt's aesthetics appeared to be spurned by a descent into the inferno of brutal and ugly, desperately laid-bare forms. And yet, after years and years, a more profound and more genuine kinship with Rembrandt was to be revealed in the art of Rouault, this time with the spirit and intangible inspiration. It is enough to look at the canvases and etchings of his final years to perceive in them a transfigured reflection of Rembrandt's sweetness, intensity, and imaginative fullness. It is beautiful to contemplate, in the evening of a painter's life, such a resurgence of the heritage—purified and spiritual—of an old master, seemingly repudiated for a time, at the very creative sources of a man who never ceased being one with him in love.

A close relationship between Rouault and Daumier has also been noted, yet this relationship remains somewhat superficial and has mainly to do, I think, with that quality of *plastic workman* which Rouault admired in Daumier as well as with his external vision of things. I would assume

10

OPPOSITE PAGE:
MR. X
Painted in 1911. Oil, 30 1/4 × 22 1/4"
Albright-Knox Art Gallery, Buffalo, New York

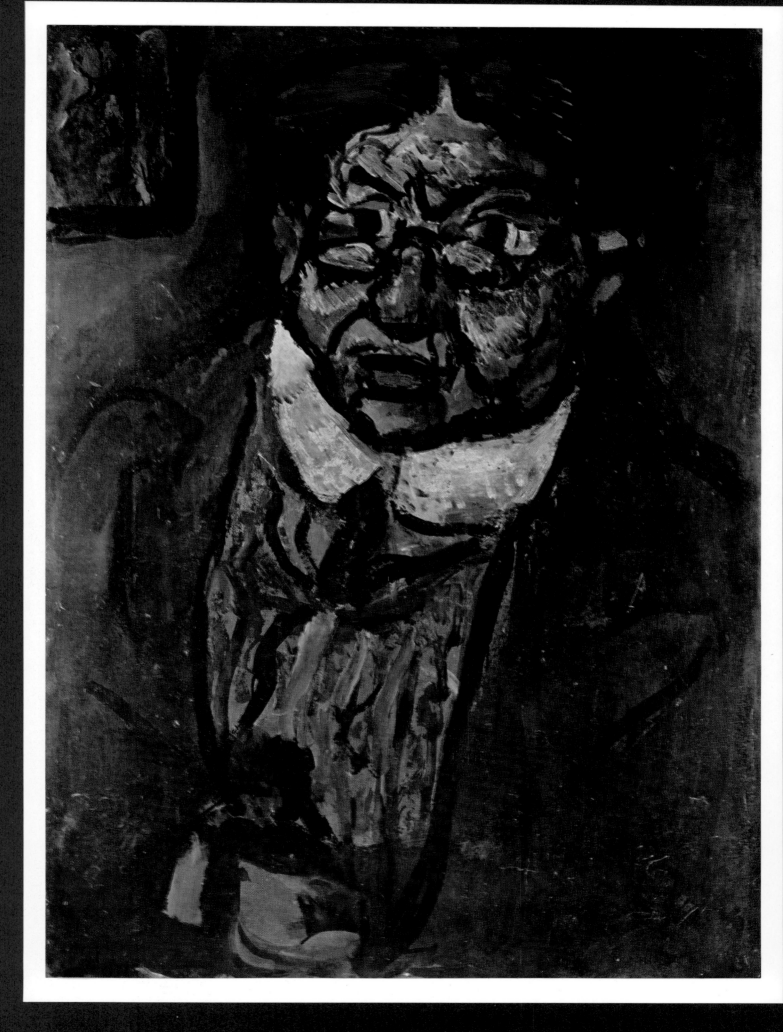

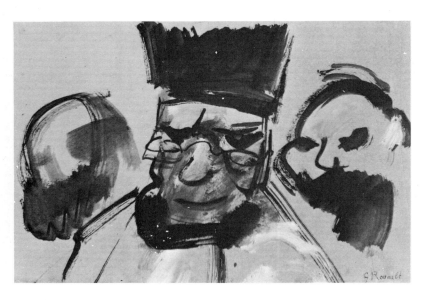

THREE JUDGES
About 1907. Oil and wash on paper
Collection Mr. and Mrs. Samuel A. Marx, Chicago

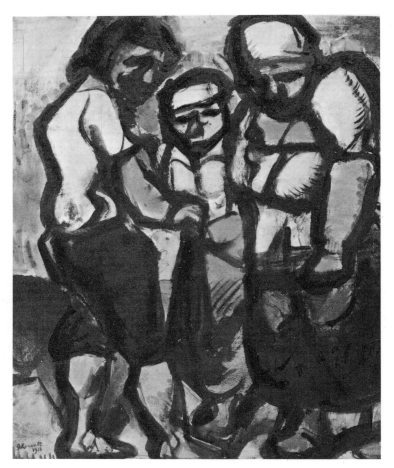

GROUP OF RUSTICS
1911. Gouache and pastel
The Norton Gallery and School of Art, West Palm Beach, Florida

that the impact of Daumier's vision was readily accepted during the first period of Rouault's research—and that Rouault freed himself from it more and more definitely, from the moment when he brushed aside not only any temptation of caricature and satirical anecdote (Daumier was a great painter, not a mere caricaturist), but also a simply pessimistic approach to reality. For tenderness and pity, and a longing for harmony, calm, and serenity are the true heart of Rouault.

Well, it is not with Daumier or even with Rembrandt that Rouault has the deepest consanguinity. It is with the genuine primitives of the Romanesque age. His similarity to them is not a matter of influence. Rather, it is a matter of nature; it has to do with the essential gifts, the native poetic perception and the native craftsman's instinct of the painter. Rouault, as a boy, was an apprentice glassworker, and his particular use of the enveloping line and of color makes him a brother of the medieval designers of stained glass windows. He is also, and in a still deeper sense, the brother of the sculptors of Romanesque bas-reliefs. "In the spontaneous search for a synthetic form in unison with religious consciousness," Lionello Venturi says in his study of the painter, "Rouault has taken us back through the centuries to that moment when every image on earth was a reflected expression of God."

12

OPPOSITE PAGE:
THREE JUDGES
Painted in 1913. Gouache and oil, 29 7/8 × 41 5/8"
The Museum of Modern Art, New York (Samuel A. Lewisohn Bequest)

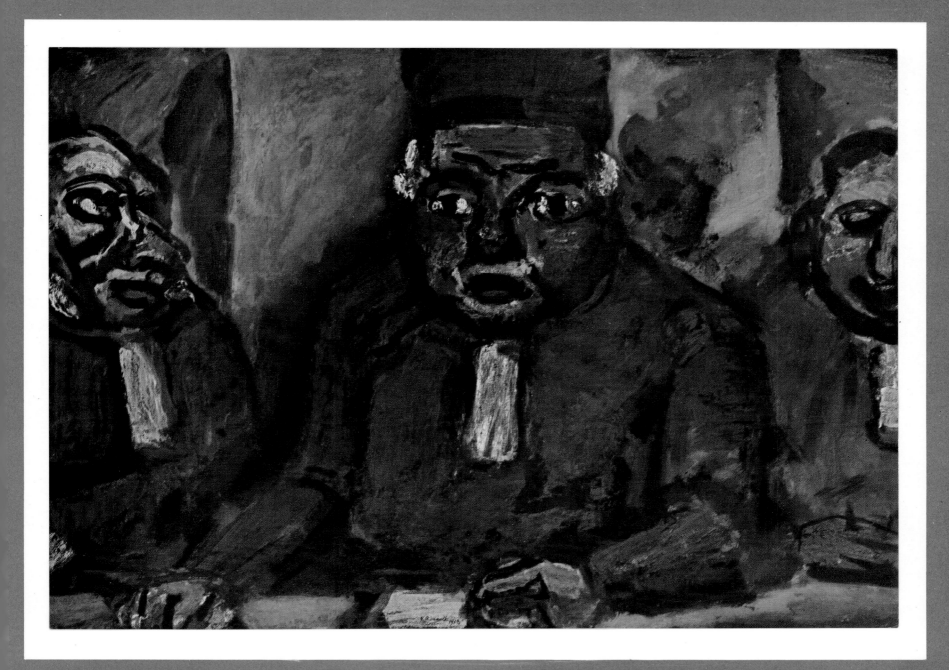

We find in Rouault's art not only a spontaneous reconciliation of revolutionary search and continuity with tradition. Much more essential, we find in it a vital unity between poetry and craftsmanship. Rouault was the son of a cabinet-maker, and he never lost contact with the working people; he had their gravity and fierce delicacy of feeling, he detested vulgarity as they do and bourgeois philistinism more than they do. And he had a passion for all the tricks and cleverness of artisan labor, as well as for "rare materials" used in the work. No painter is richer in craftsman's knowledge, shrewdness, and sensitive accuracy. But all this was totally and absolutely subordinate in him to that "search for an internal order" and those "inner promptings," to that interior lyricism of which he often spoke, and to the freedom of creative emotion. Thus it is that, loathing "plans and programs fixed beforehand," he discovered the organic necessities and requirements, the *truth* of each one of his works by plunging, as Cézanne did, deep into the ocean of pictorial matter, and listening with savage attention to the perfect singularity of his perceptive feeling. "Le dessin," he said, "est un jet de l'esprit en éveil" (Drawing is a gush of the spirit on the alert).

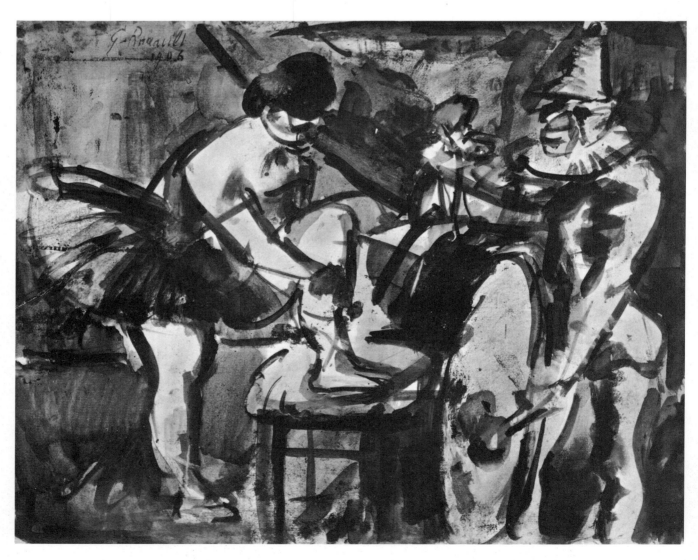

CIRCUS
1906. Gouache
Collection
Mrs. Dudley Thayer,
West Grove,
Pennsylvania

14

OPPOSITE PAGE:
THREE CLOWNS
Painted in 1917. Oil, 41 × 29 1/4"
Collection Mr. and Mrs. Joseph Pulitzer, Jr., St. Louis

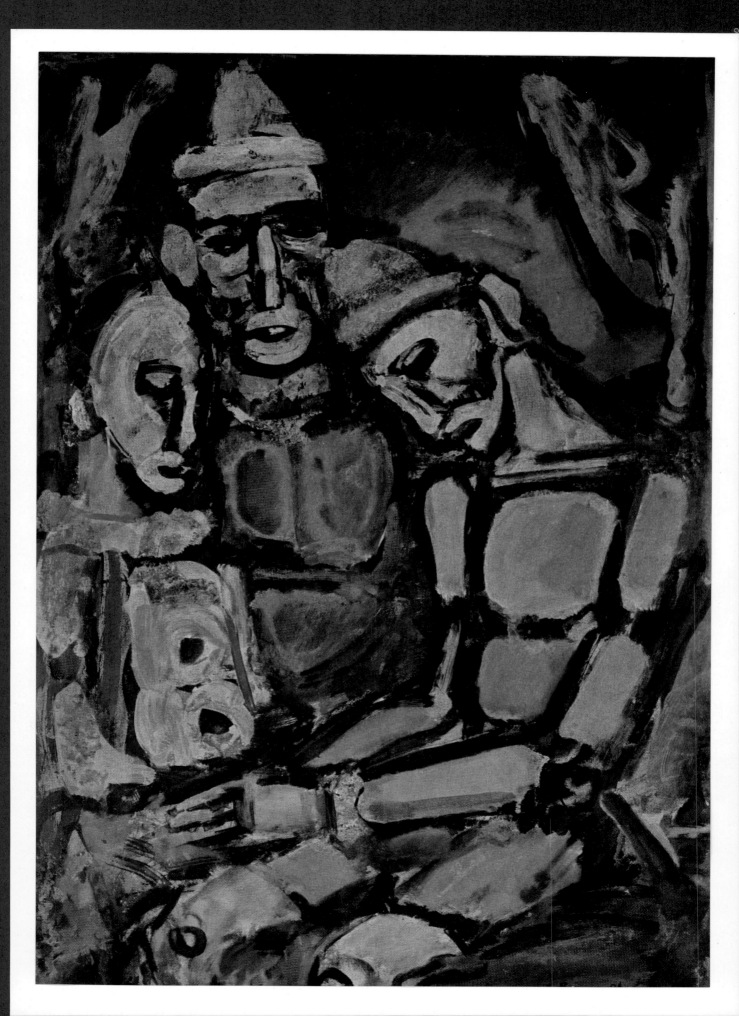

This unity of creative emotion and the working reason—with unconditional primacy of creative emotion over all the rest—is a native privilege of any great artist. But it comes to perfection only as the final victory of a steady struggle inside the artist's soul, which has to pass through trials and "dark nights" comparable, in the line of the creativity of the spirit, to those suffered by the mystics in their striving toward union with God. Such was the case with Rouault. I have stressed elsewhere (in *Art and Poetry*) his disinterestedness and courage, and "the *purity*—almost Jansenist, and which could become cruel—that makes his force and liberty."

The same virtues were at work in the achievement of another victory, which also has to do with the mystery of artistic creation; it is a victory which all the great masters of modern painting have similarly won, in one way or another, but one wonders whether the generation dedicated to non-representational art may lay claim to it. I mean that the modern artist is endowed by his time with

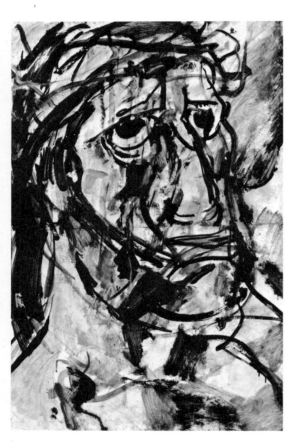

HEAD OF CHRIST
1905. Oil
Collection Walter P. Chrysler,
New York

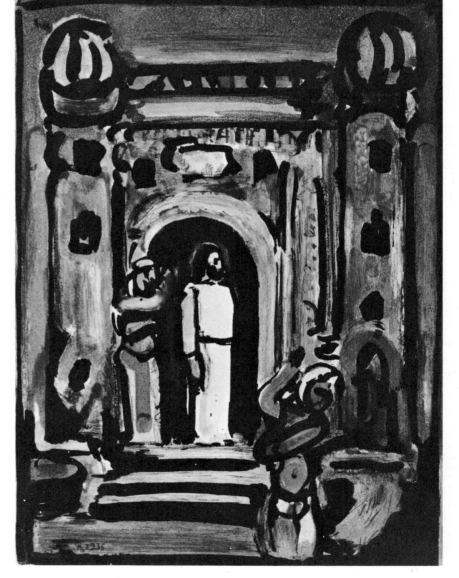

CHRIST BEFORE THE CITY
1939. Color etching and aquatint.
From André Saurès' Passion

16

OPPOSITE PAGE:
CRUCIFIXION
Painted about 1918. Oil and gouache, 41 1/4 × 29 5/8"
Collection Henry P. McIlhenny, Philadelphia

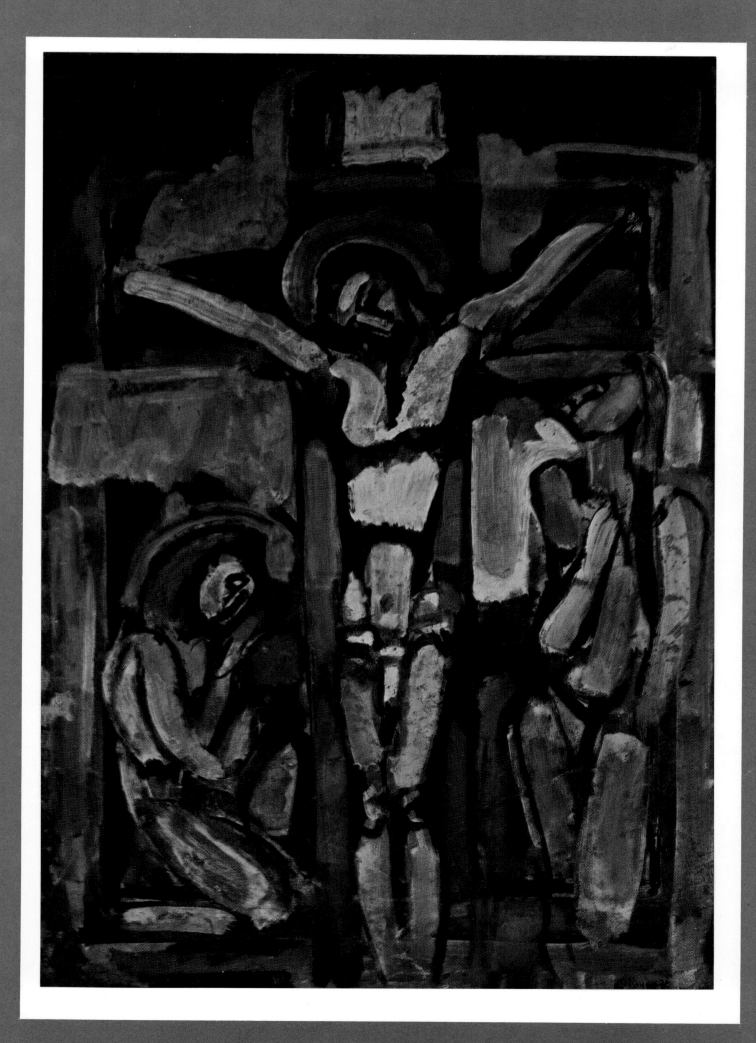

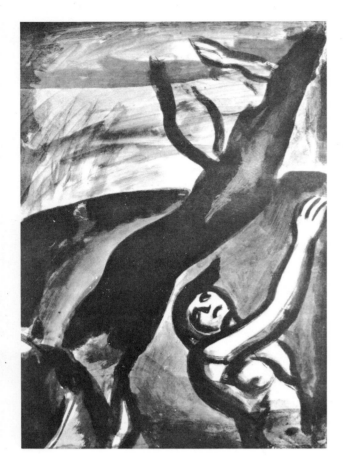

TOMORROW WILL BE BEAUTIFUL,
SAID THE SHIPWRECKED MAN...
1922. Aquatint and drypoint.
From the Miserere *series*

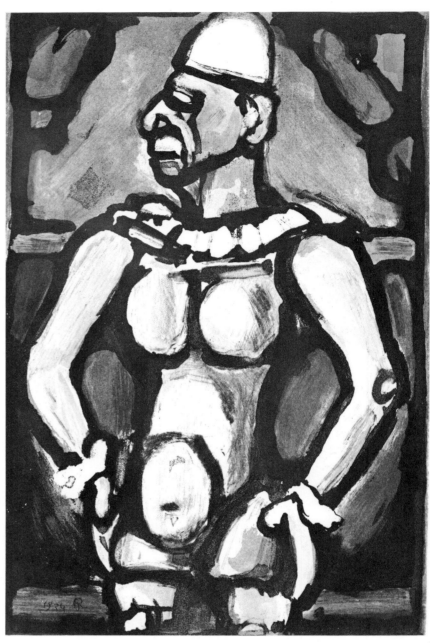

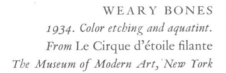

WEARY BONES
1934. Color etching and aquatint.
From Le Cirque d'étoile filante
The Museum of Modern Art, New York

a unique privilege, given him by the progress in self-awareness made in the course of a century: he knows that the poetic process and the work of art are a revelation of the creative Self; and, by the same token, he is given an unheard-of freedom. But this very privilege and very freedom are his risk and danger too. For in turning toward his own inwardness and looking for his own subjectivity to grasp and express, he may become divided from things and imprisoned in himself; he may lose at the same time the poetic spark of creativity, and the sense of the very work to be done—if he forgets that the creative Self cannot possibly be revealed except in the joint revelation of the reality and trans-reality of things, and of some secret meaning grasped in them. Why? Because it is in awakening to things that creative subjectivity awakens to itself, in and through that obscure and

OPPOSITE PAGE:
THE HUMANE LANDSCAPE
Painted in 1937. Oil, 25 1/2×39″
Collection Mrs. Nate B. Spingold, New York

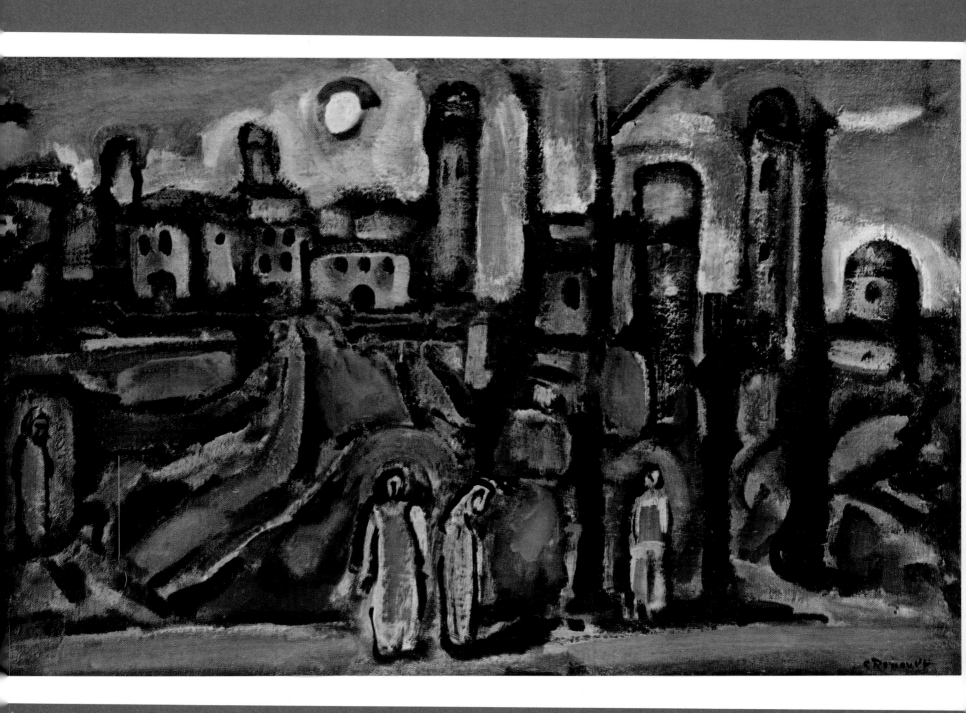

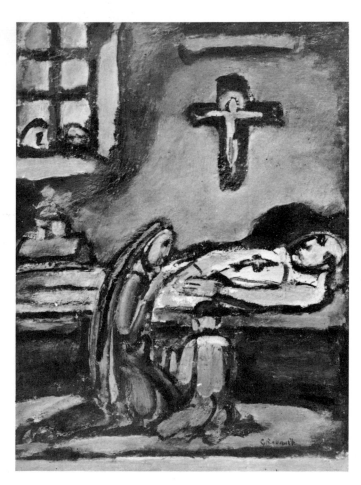

DE PROFUNDIS
1946. Oil
Musée National d'Art Moderne, Paris

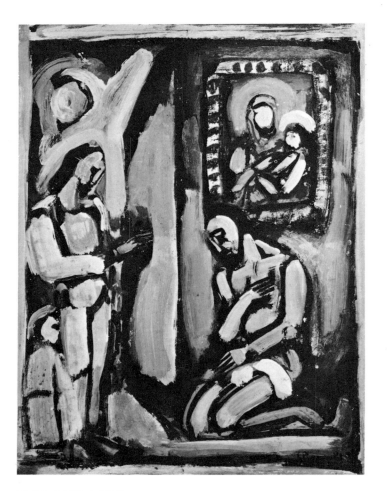

THE MIRACLE
About 1935. Oil on paper, mounted on board
Memorial Art Gallery of the University of Rochester, New York

emotional knowledge—inexpressible by concepts, expressible only by the work—which is poetic knowledge, and in which subjectivity itself is made into a means of grasping the world.

At this point I should like to emphasize an essential aspect of the art of Rouault, which results from that primacy of creative emotion I just mentioned. It is true to say of the pictures of Rouault, as of those of the other great modern painters, that each one is an ideogram of himself. But each one is also, and by the same token, an ideogram of the mystery of things—of some interior aspect and meaning caught in the reality of the visible world, whose forms and appearances, before being recast in a new fabric on his canvas, are scrutinized by an eye implacably attentive to the most fleeting signs and nuances. Both the humility and the boldness of this painter were too great for him to turn away from that "spectacle displayed before us by *Pater Omnipotens Aeterne Deus*" of which Cézanne spoke. No painting, in our time, clings more closely than Rouault's to the secret substance of visible reality, which is there, present, inescapable, existing on its own, sometimes aggressively. This kind of "realism" is in no way realism of material appearances; it is realism of the spiritual significance of what exists (and moves, and suffers, and loves, and kills); it is realism permeated with

OPPOSITE PAGE:
THE FUNERAL
Painted in 1930. Gouache and pastel, 11 × 19 3/8″
The Museum of Modern Art, New York

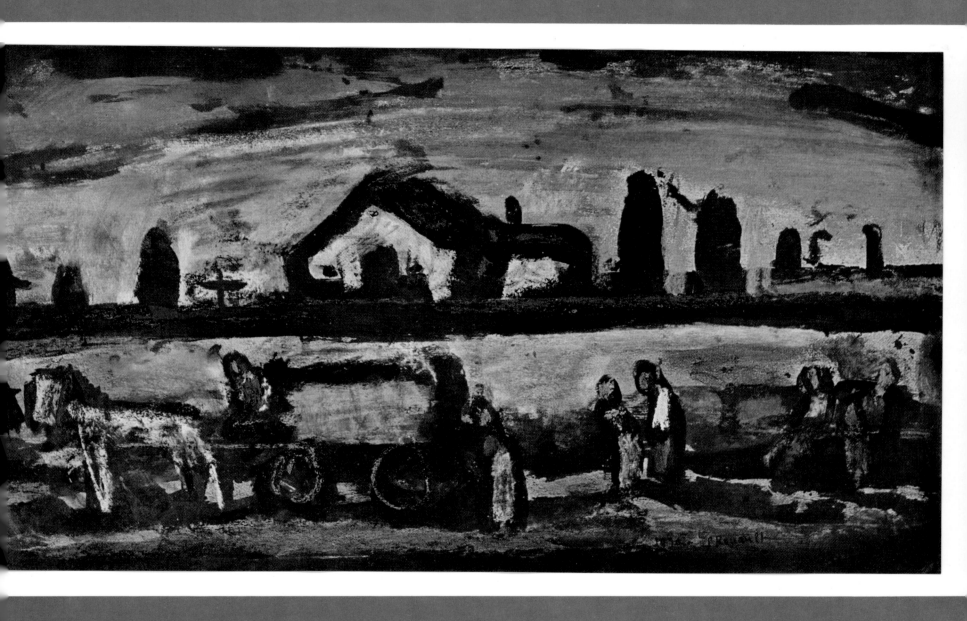

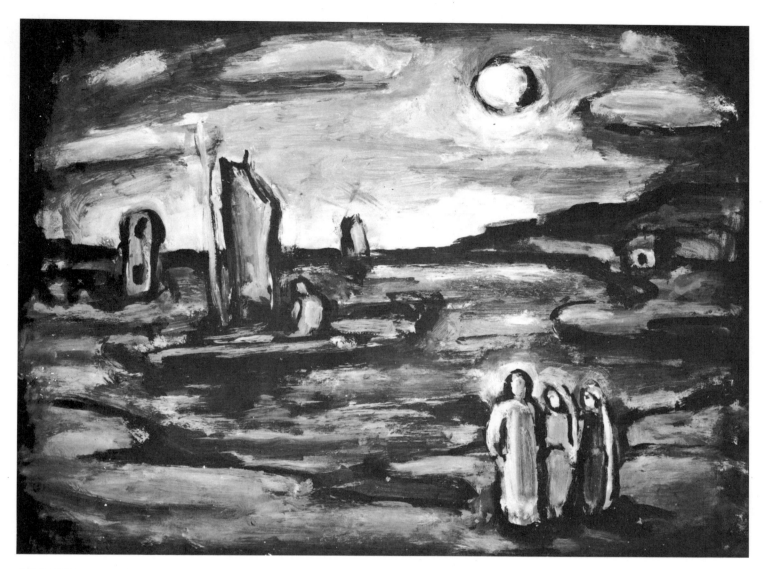

CHRIST AND THE FISHERMEN
1941. Oil
The Philadelphia Museum of Art

the signs and dreams that are commingled with the being of things. Rouault's realism is transfigurative and it is one with the revealing power and poetic dynamism of a painting which remains obstinately attached to the soil while living on faith and spirituality. There is no abstraction in it, save that abstraction which brings out from things the meanings with which they are pregnant, and re-creates on the canvas or the paper the essentials, and just the essentials, of their significant elements. As regards means of expression, the preoccupation with plastic qualities always remained central for Rouault. This preoccupation was linked in him with an anxious and touchy determination to get rid of any "literature" in the work, and to have the painting affirm itself only as painting. That is why the concern for the *contour* haunted Rouault as strongly as it did Cézanne. Like Cézanne he groaned, "Le contour me fuit" (The contour escapes me). And he added: "Ce mot lapidaire ré-

OPPOSITE PAGE:
CHRIST MOCKED BY SOLDIERS
Painted in 1932. Oil, 36 1/4 × 28 1/2"
The Museum of Modern Art, New York

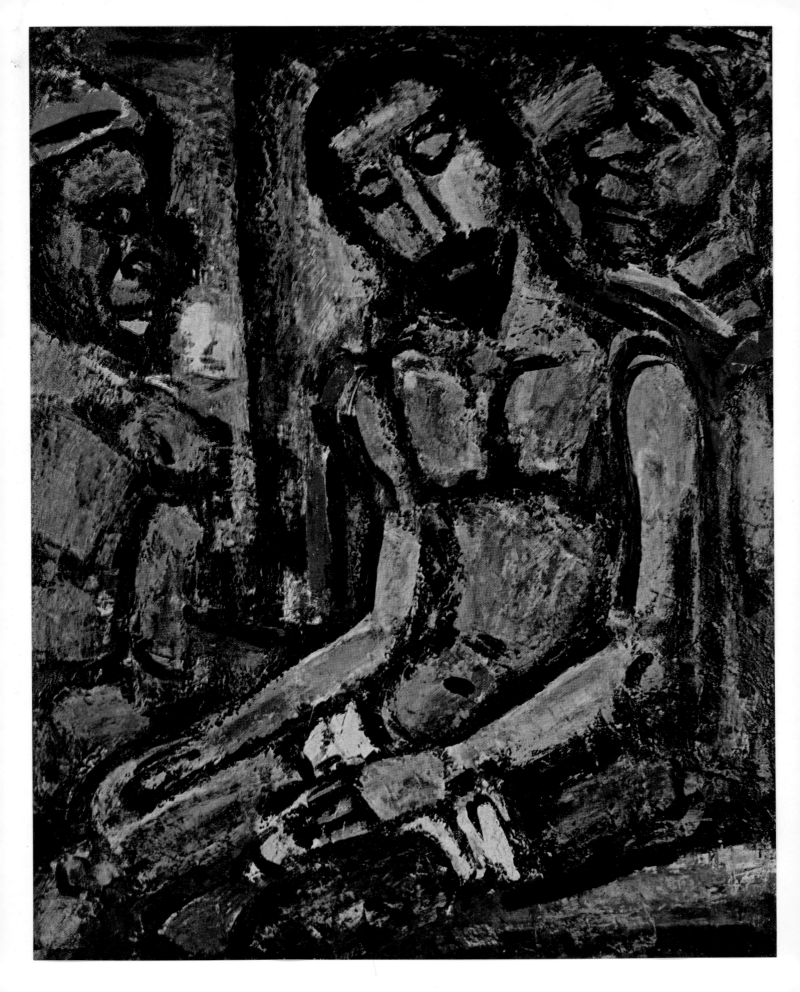

THIS WILL BE THE LAST TIME,
LITTLE FATHER!
*1927. Etching and aquatint.
From the* Miserere *series*

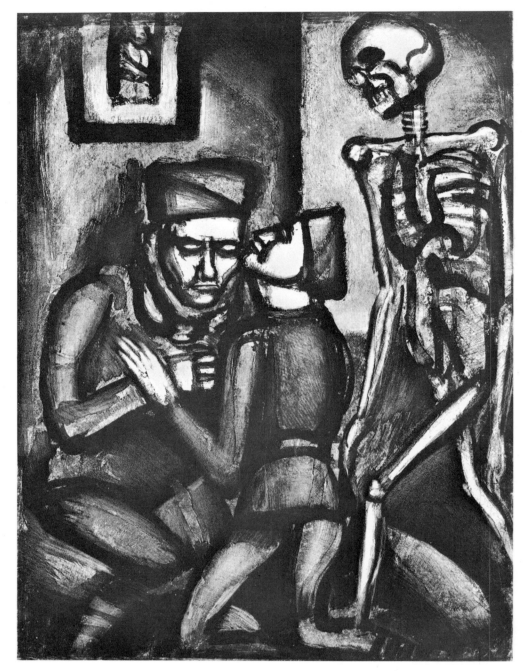

sume toute la peinture et va bien au delà" (This lapidary word summarizes all painting and goes far beyond).

The preceding remarks enable us to realize that an art so conscious and powerful in its means and so deeply rooted in creative emotion has been able to assume without bending a heavy burden of humanity. It is not without the reason of a profound affinity that Rouault was the friend of Huysmans and above all of Léon Bloy. Bloy did not understand anything of his painting and directed at him the most cruel and merciless reproaches; Rouault stood immobile, white with repressed anger, mute. He probably murmured in his heart, at such moments, the saying of Poussin which was dear

24

OPPOSITE PAGE:
CHRIST AND TWO DISCIPLES
Painted in 1937 or 1938. Oil, 27 1/2 × 21 1/2"
Collection Julian and Joachim Jean Aberbach, Hollywood, California

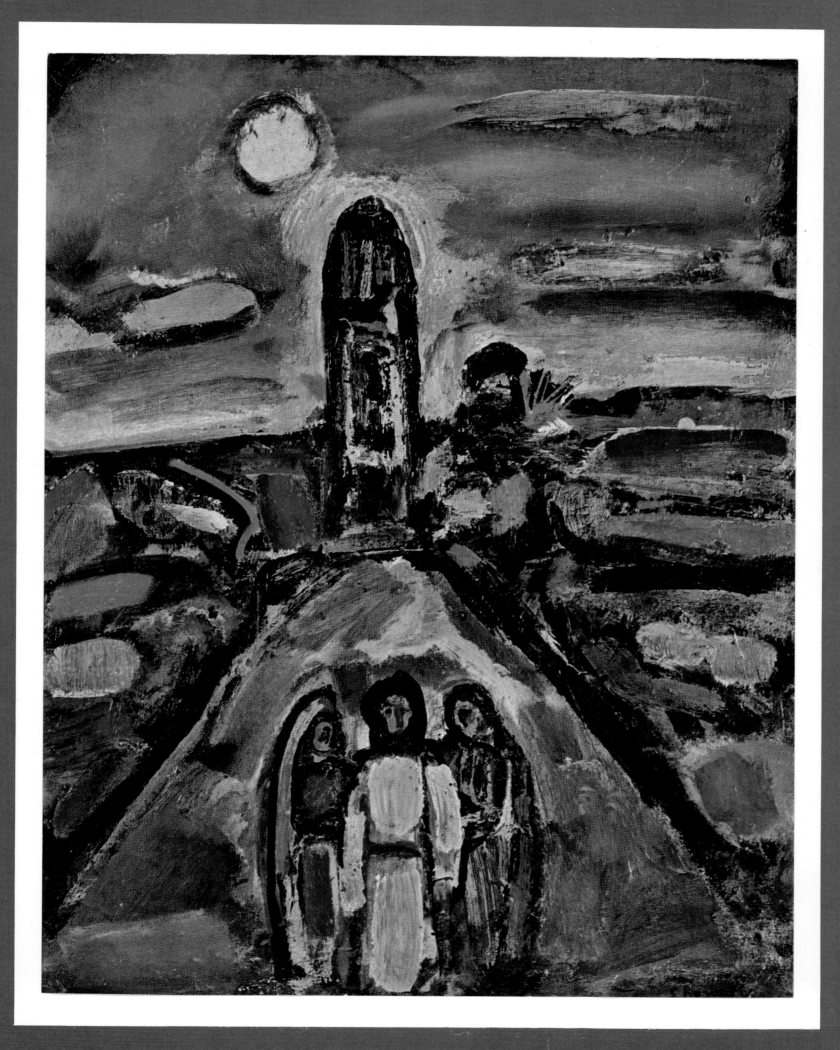

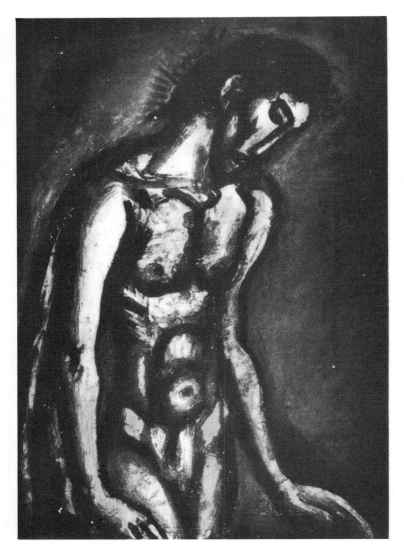

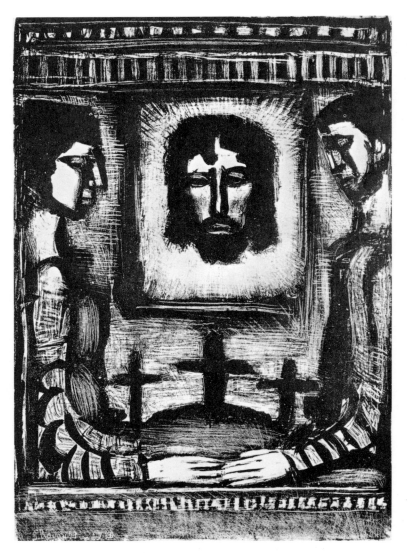

"HE WAS OPPRESSED, AND HE WAS AFFLICTED,
YET HE OPENED NOT HIS MOUTH . . ." (Isaiah, 53 : 7)
About 1922. Etching and aquatint.
From the Miserere *series*

VERONICA'S VEIL
1930. Lithograph

to him : "We are producing a mute art." But in Bloy he found the intellectual certitudes he needed, and the justification of his revolt against the baseness and hypocrisy of a loveless world—and a sense of suffering and religious contemplation akin to his own. I remember this time with particular emotion. No art dealer was yet interested in him. The few friends and lovers of painting who trusted him were afraid of the direction he had decidedly taken from 1903 on. He was busy with ferocious images through which he discharged his anger; he depicted heartless and ugly judges, pitiable clowns, prostitutes, shrews, smug and arrogant upper-class ladies; he seemed committed to become the painter of original sin and of the misery of wounded humanity. But there already appeared "figures of Christ with the face and body prodigiously deformed to express the paroxysm of the divine Passion and human cruelty." "Thus it was," Raïssa Maritain says (in *Adventures in Grace*), "that

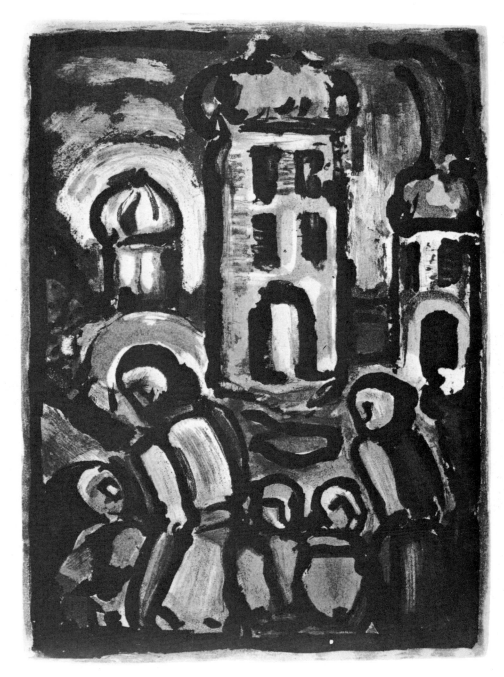

CHRIST AND THE CHILDREN
1935. Color etching and aquatint. From André Saurès' Passion

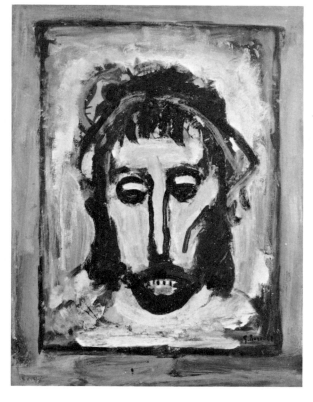

THE SPANISH CHRIST
1936. Oil
Formerly collection Mr. and Mrs. Vladimir Golschmann

27

he uttered his horror of moral ugliness, his hatred for bourgeois mediocrity, his vehement need of justice, his pity for the poor—finally his lively and profound faith, as well as his need of absolute truth in art. This enormous load seeking ways of expression would have caused a less firmly rooted virtue of art to bend. In Rouault it gave but greater stature to the artist himself. Far from making him deviate, this spiritual mass weighed only in the direction of the most absolute requirement for genuine expression in a work—according, that is, to the most absolute requirement of art."

It was not difficult to perceive that, in this dark period, the prime incentive which moved the feelings of the painter was in reality a desperate yearning for peace and hope and fraternal generosity among men; it was compassion and love. "Beauty is the form that love gives to things," Ernest Hello said. How could ugliness not spoil the forms of a world which love seemed to have quit? "I believe in suffering," Rouault wrote, "it is not feigned in me. This is my only merit. I was not made to be so terrible."

He emerged from this dark period by virtue of the inner necessities of the process of growth of his art. To the extent to which his own spiritual experience became deeper, creative emotion was to take place also in deeper regions of his soul, further from the noise of the external world; and at the same time the exigencies of the plastic expression developed a purer and freer urge toward harmonic expansion. As a result, Rouault's painting entered a sphere of growing light and clarity. It disclosed

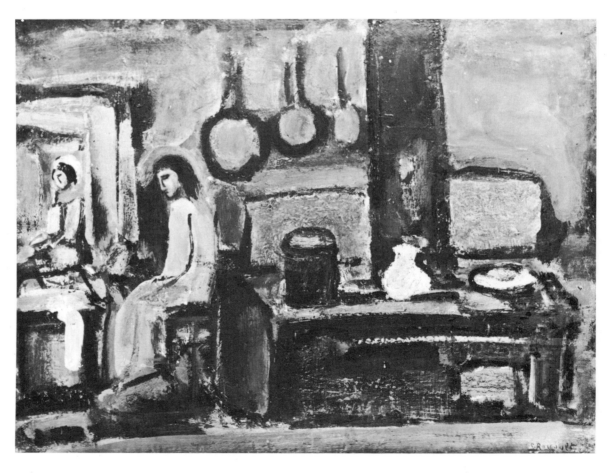

IN THE OLD QUARTER
1937. Oil
Collection Julian and Joachim Jean Aberbach,
Hollywood, California

28

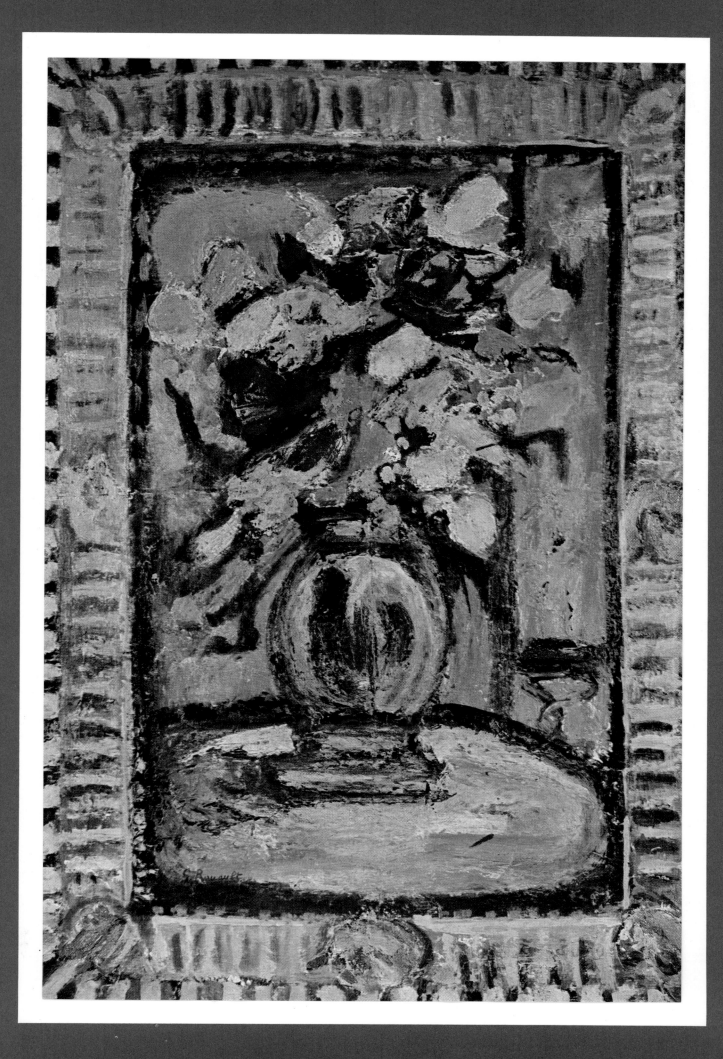

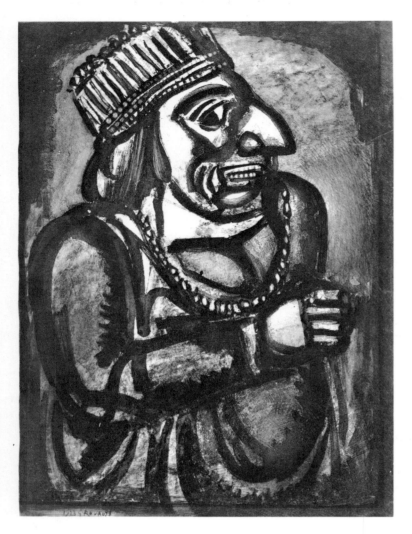

WE THINK OURSELVES KINGS
1923. Aquatint and drypoint.
From the Miserere *series*

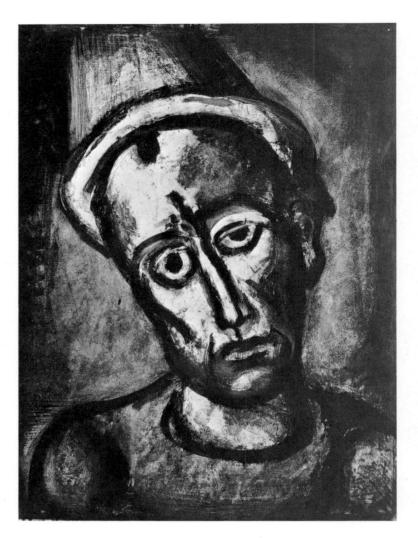

WHO DOES NOT PAINT HIMSELF A FACE?
About 1922. Etching and aquatint.
From the Miserere *series*

to us, more and more manifestly, a plenitude of volumes, a lively elegance of the arabesque, and a rigorous and severe harmony which appear in the glory of exquisitely nuanced and sumptuous color and the transparency of the most precious matter. A touch of Greek order and beauty even passes sometimes in the work and strikes our eyes—just as in certain statues of medieval cathedrals. Compassion and pity are always there, extending to all the distress of the human condition. But bitterness and anger have been superseded both by larger emotion and by a dominating sense of the musical nobility of forms. All that is summed up, so to speak, in the admirable plates of the *Miserere*.

This could all be sensed from the start in those landscapes which are, to my mind, one of the most moving and powerful parts of the work of Rouault. Landscapes of dream and misery, in which the element of romanticism that existed in the painter is less repressed than elsewhere—their infinite melancholy is that of human distress and abandonment assumed and purified by the peace and serenity of a compassionate nature.

OPPOSITE PAGE:
THE OLD KING
Painted 1916–36.
Oil, 30 1/4×21 1/4″
Carnegie Institute, Pittsburgh

30

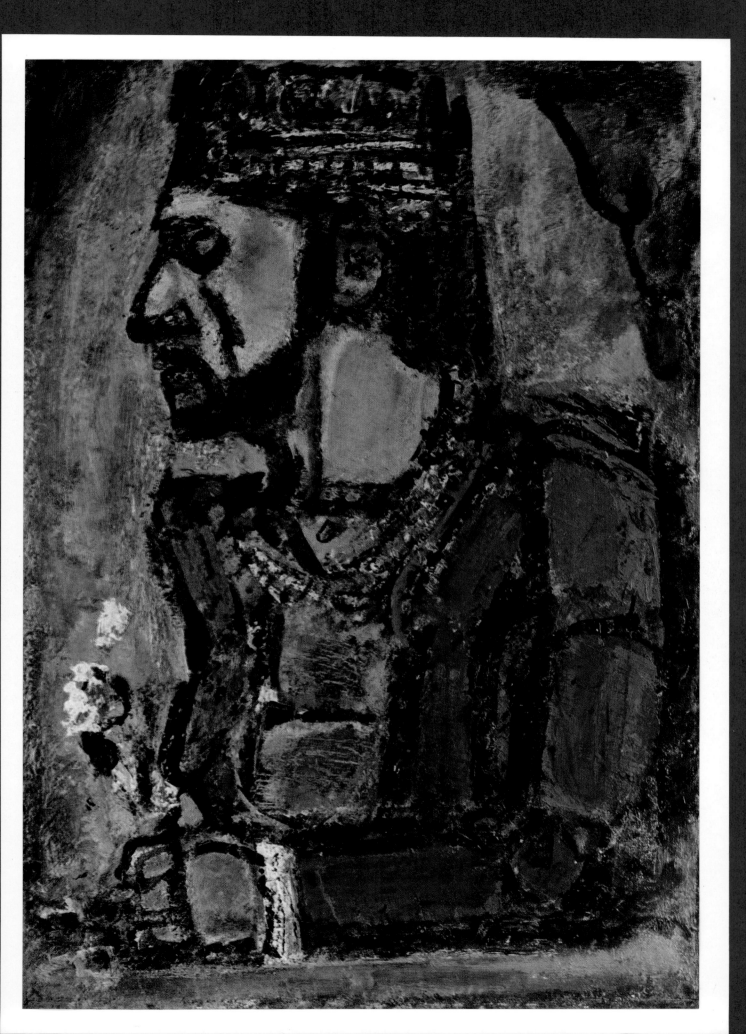

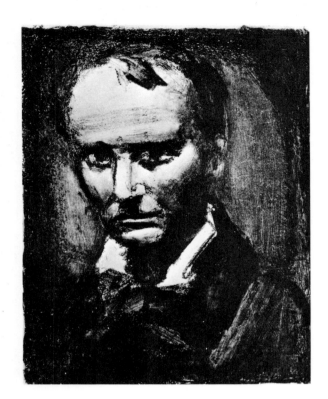

CHARLES BAUDELAIRE
About 1924–27. Lithograph

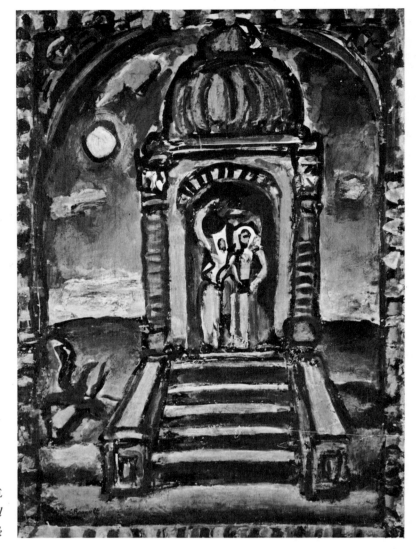

OASIS OR MIRAGE
1944. Oil
Collection Mr. and Mrs. William S. Paley, New York

Yet it was in the field of religious art that the steady ascent toward light of which I am speaking most definitely manifested itself. Even at the time of his enraged pictures of a cruel and sinful world, Rouault worked at religious subjects. Here we are in the presence of a lifelong effort which was never interrupted. But with his extraordinary patience and his sense (this is a secret of his power) of the natural maturation of living forces which must never be artificially hurried, Rouault waited for the moment when the essential orientation of his heart, and his hard struggle toward calm and clarity, would overcome the entanglements of art and matter and gain definitive mastery. He is now recognized as the greatest religious painter of our time, one of the greatest religious painters of the ages. This was a triumph of evangelical feeling and of spiritual inwardness taming and lifting a ferocious art of the human abysses and of the obscure splendor and vitality of earthly matter. In his scenes of the Passion, paroxysmic deformation has been superseded by the majesty of a suffering which, before coming from the wickedness of tormentors, comes from the very will of the Lamb of God offering Himself by love. The imprint of Christ's face on Veronica's veil, which

32

OPPOSITE PAGE:
PORTRAIT OF VERLAINE
Painted about 1938. Oil, 39 3/4 × 29 1/8"
The Phillips Collection, Washington, D.C.

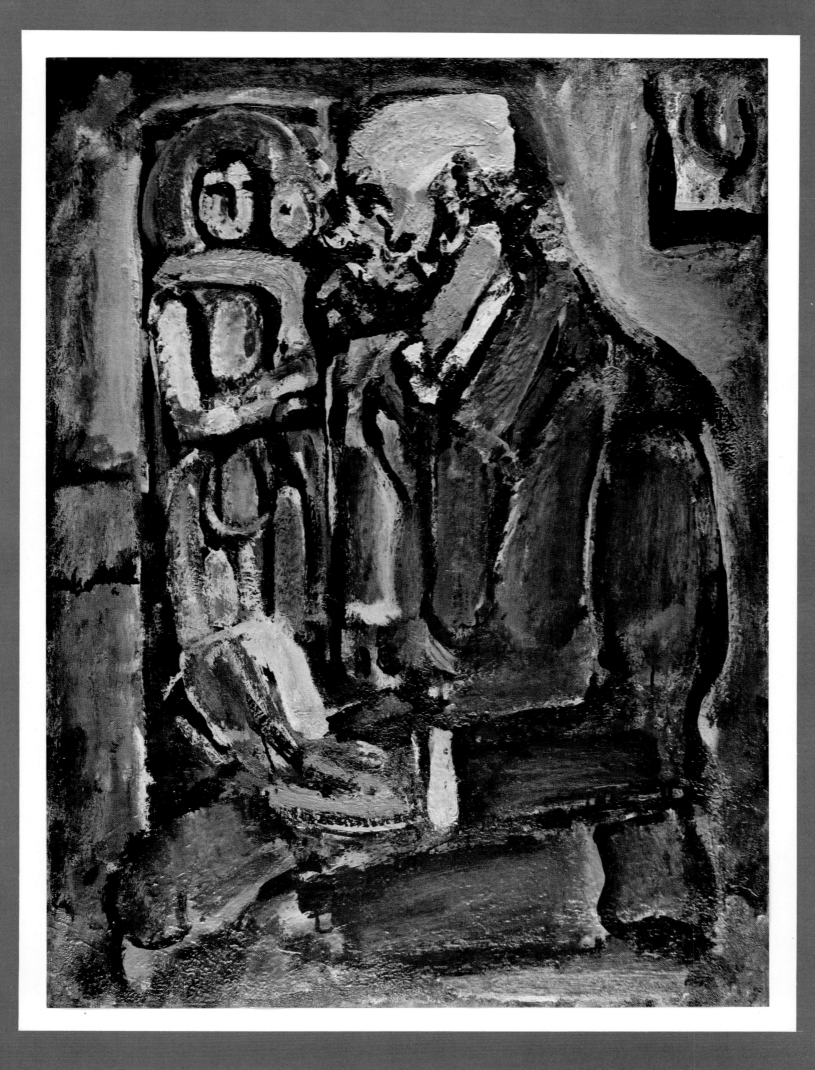

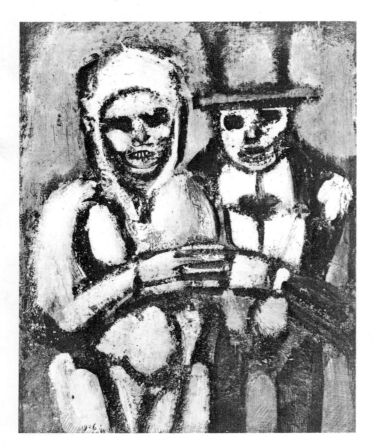

BRIDE AND GROOM
1926. Etching and aquatint.
From Les Fleurs du mal

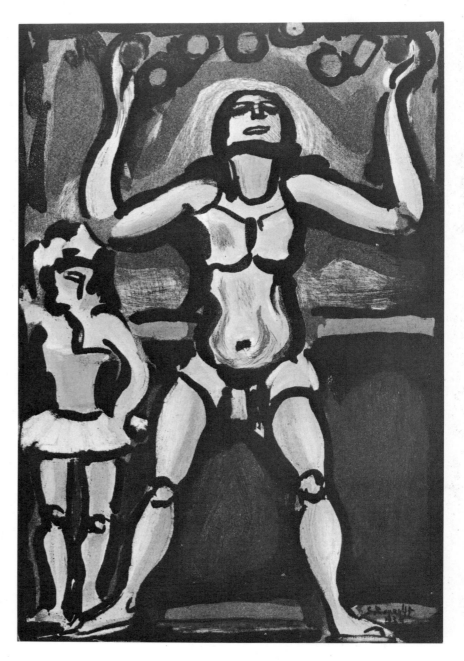

JUGGLER
1934. Color etching and aquatint.
From Le Cirque d'étoile filante

Rouault never tired of depicting, seemed to mean for him the imprint of divine mercy on human art. We cannot overemphasize the importance of the renewal that religious painting owes to Rouault. As Maurice Morel rightly pointed out, the image of the Crucifixion, the "capital sign of Christianity," has been freed by him from that academicism to which it seemed condemned for two centuries, even in the works of great painters. Let us stress this significant fact: it was through the inspiration of his faith, and of the contemplative promptings which were his hidden treasure, that the abiding poetry, the flash of poetic intuition which quickened the art of Rouault reached full freedom and full scope, in a painting which, more than ever, remained strictly painting. Thus it was that "the most humanly and morally pathetic art of our time" was raised to hieratic grandeur.

OPPOSITE PAGE:
THE ENGLISH CLOWN
Painted 1938–39. Oil, 25 3/4×17"
Collection Stavros Niarchos

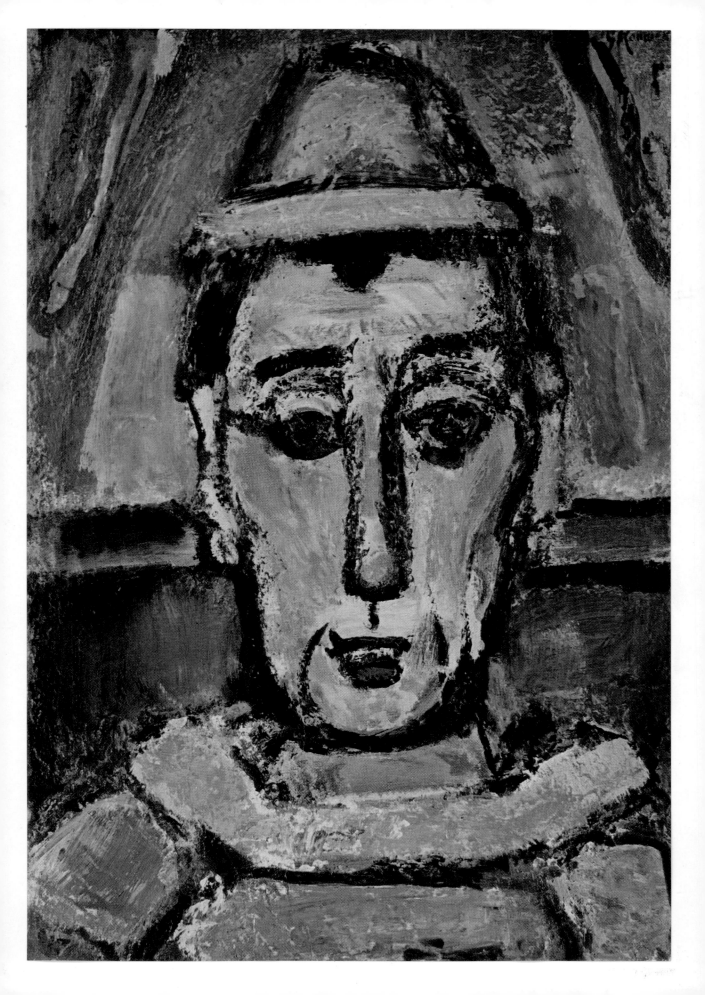

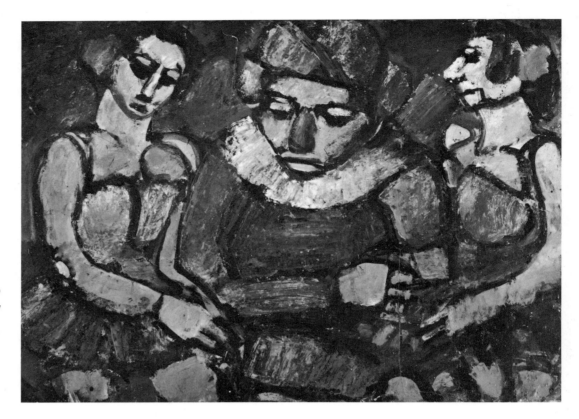

CIRCUS TRIO
About 1930. Oil
The Phillips Collection, Washington, D.C.

At the end of his preface to the last edition of the *Miserere*, Rouault printed one of the naïve songs in which he communicates to us some of his thoughts:

Form, color, harmony
Oasis or mirage
For the eyes, the heart, or the spirit
Toward the moving ocean of pictorial appeal

"Tomorrow will be beautiful," said the shipwrecked man
Before disappearing beneath the sullen horizon

Peace seems scarcely to rule
Over the anguished world
Of shadows and appearances

Jesus on the Cross will tell you better than I
Jeanne at her trial in her brief and sublime replies
As well as the obscure or consecrated
Saints and martyrs.

Let us read the painter's lines before carefully examining the remarkable plates contained in this book. * * *

36

OPPOSITE PAGE:
THE WISE PIERROT
Painted in 1945. Oil, 29 1/2 × 22"
Collection Mr. and Mrs. Alex L. Hillman, New York

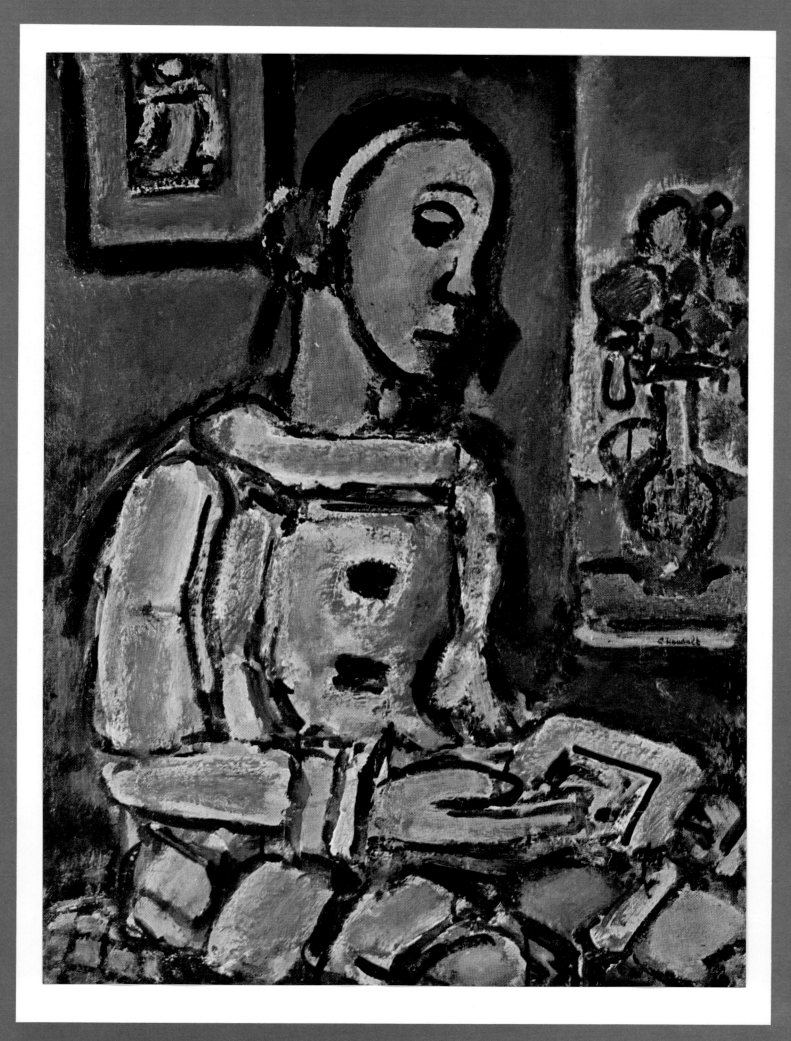

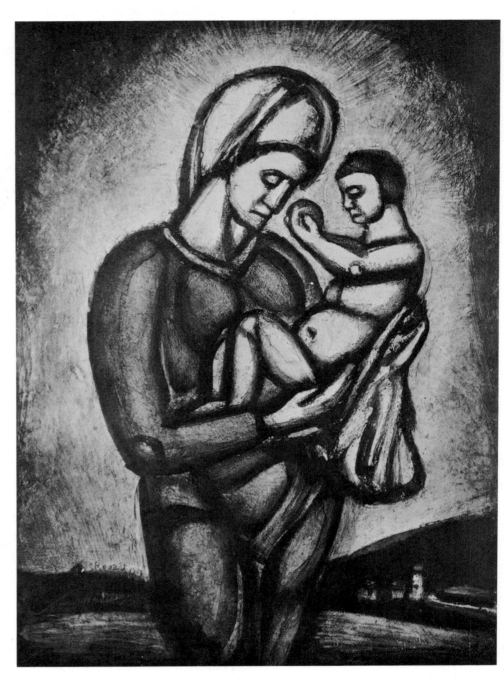

IN THESE DARK TIMES
OF VAINGLORY AND UNBELIEF,
OUR LADY OF LAND'S END
KEEPS VIGIL
1927. Etching and aquatint.
From the Miserere *series*

It is of course impossible for a limited number of pictures chosen from an immense production to cover all the aspects of a work like that of Rouault. More plates would be needed, in particular, to illustrate the final stages of that slow ascent I mentioned above toward hieratic balance in religious painting and, more generally, toward classical nobility of form—though the freedom and elegance of the contours in the *Seated Clown* already appear quite significant in this regard. The fact remains that the pictures reproduced in this volume are enough to give us an idea of the main tendencies and the various approaches to the universe of painting which are at play in the work of Rouault. Here we have the painter of translucid matter (*Bouquet,* 1938; *Three Clowns,* 1917), the painter of sinful and

38

OPPOSITE PAGE:
THE FLIGHT INTO EGYPT
Painted in 1948. Oil, 14 1/2×13″
Private collection, Paris

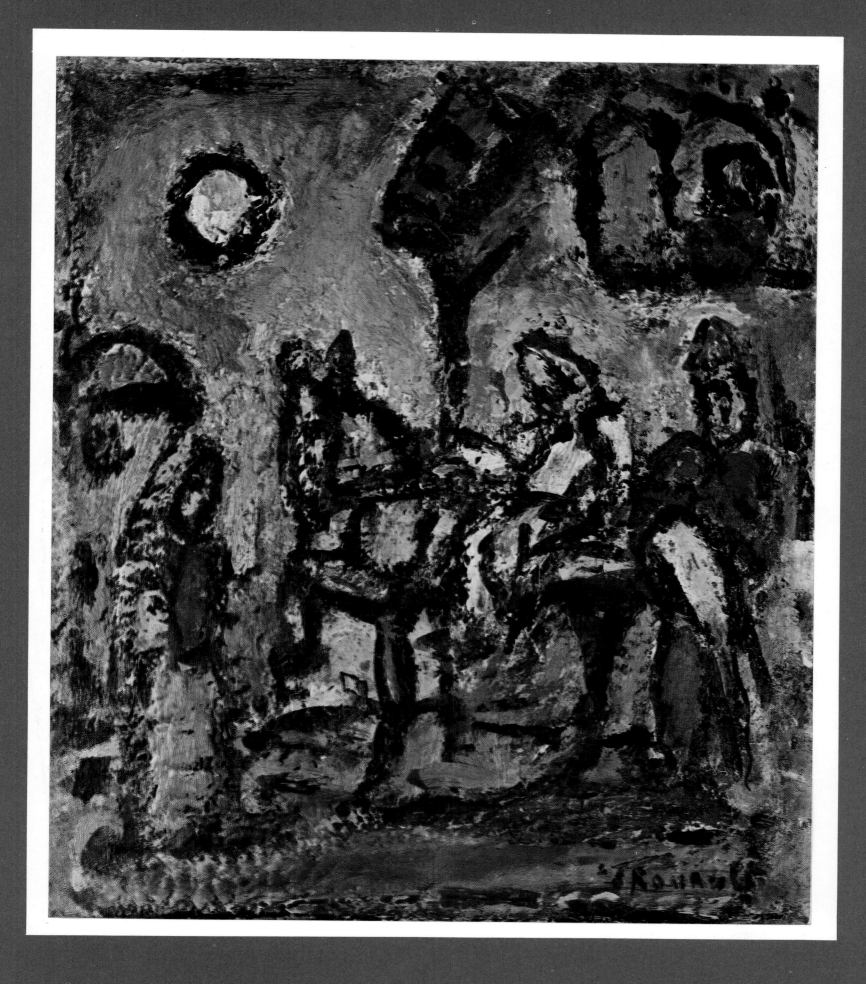

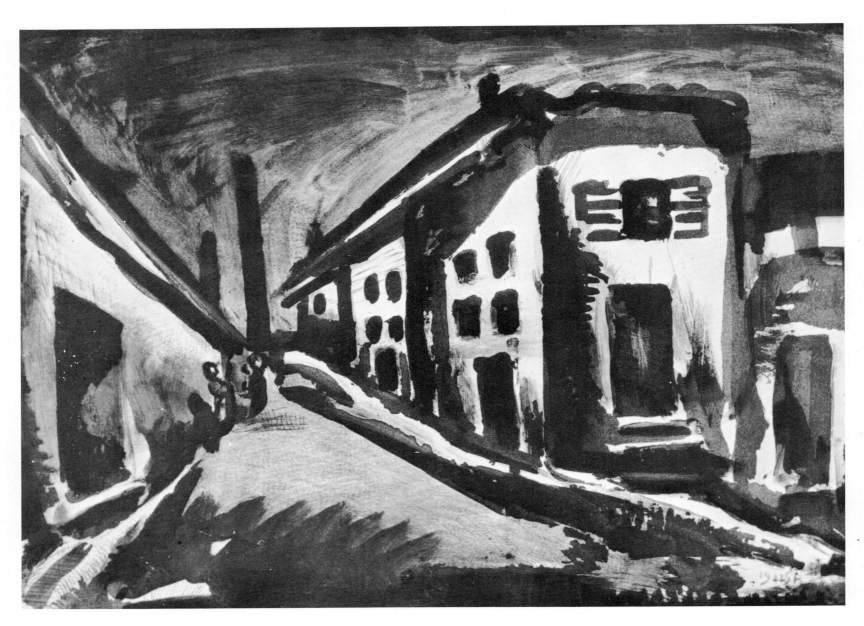

STREET OF THE LONELY
1922. Etching and aquatint
From the Miserere *series*

pitiable flesh (*Three Nudes*, 1907), the painter of the dereliction and agony of Christ (*Christ Mocked by Soldiers*, 1932; *Crucifixion*, 1918), the painter of landscapes in communion with the dreams and sorrow of man (*The Funeral*, 1930). A striking synthesis of the exclusively pictorial *poetry* of Rouault appears in that extraordinary landscape, *Christ and Two Disciples* (c. 1937), which conveys to our eye and our heart, in one single intuitive flash, the nostalgic clamor of a world illumined by the blood and compassion of its Saviour. Through its musical intensity of color and its liberty of transfigurative imagination this canvas is in my opinion one of the most revealing works of Georges Rouault.

40